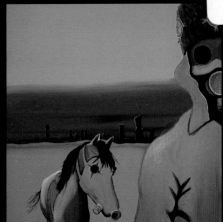

VISIONS FOR THE FUTURE

A Celebration of Young Native American Artists

VOLUME I

Native American Rights Fund

Fulcrum Publishing
Golden, Colorado

Library of Congress Cataloging-in-Publication Data
Visions for the future / Native American Rights Fund.
 p. cm.
 ISBN-13: 978-1-55591-655-8 (pbk.)
 1. Indian art--North America. 2. American literature--Indian authors.
3. Indians of North America--Civil rights. I. Native American Rights
Fund.
 E98.A7V57 2007
 323.1197--dc22

 2007031347

Printed in China by P. Chan and Edward
0 9 8 7 6 5 4 3 2 1

Cover and interior design: Jack Lenzo
Front cover image: *Tribal Law* by Bunky Echo-Hawk
Back cover images: *Our Past Must Guide Our Future* by Alyssa Macy; *Insurgents* by Thomas Ryan Red Corn; *Pan-Indian Movement* by Cara McDonald

Native American Rights Fund
1506 Broadway Street
Boulder, Colorado 80302
303-447-8760
www.narf.org

Fulcrum Publishing
4690 Table Mountain Drive, Suite 100
Golden, Colorado 80403
800-992-2908 • 303-277-1623
www.fulcrumbooks.com

To the current, up-and-coming,

and future generations of young Native Americans.

To our elders and our ancestors.

And to all those warriors who have taken a stand

in the name of the rights of Native peoples, tribal sovereignty,

and the protection of our cultural and spiritual lifeways.

Contents

Artist Invitation...1

Introduction: Bridging Generations through Art, Culture,

 Music, and the Struggle for Native American Rights and Justice2

The Sovereign Circle by journalist Jenni Ghahate-Monet

 (Laguna, Zuni, Choctaw, Turtle Mountain Chippewa).............................4

In Honor of the Seventh Generation by *ina* ("mother"), social worker, activist,

 and writer Tara Weber Pretends Eagle (Hunkpapa Lakota)....................11

Bullets in the Chest, Arrows in the Back

 by artist Bunky Echo-Hawk (Pawnee/Yakima).......................................18

Culture Shock Camp..27

Bunky Echo-Hawk's Live-Art Performance..31

Featured Artists

Mathew Barkhausen III (Tuscarora/Cherokee) ..32

Duane Dudley (Choctaw)..36

Bunky Echo-Hawk (Pawnee/Yakama) ...40

Nadya Kwandibens (Ojibwe)..44

William Lewis (Dine)..46

Alyssa Macy (Confederated Tribes of Warm Springs)....................................48

Daniel McCoy Jr. (Muscogee Creek/Potawotami)....................................52

Cara McDonald (Chemehuevi)....................................56

Valerie Norris (Red Lake Nation)....................................60

Victor Pascual (Navajo)....................................66

Thomas Ryan Red Corn (Osage)....................................70

Duane Redeye (Seneca)....................................76

Dawn Webster (Seneca)....................................80

Micah Wesley (Muscogee/Kiowa)....................................82

Best in Show....................................85

Acknowledgments....................................87

Modern Day Warrior Campaign....................................89

Artist Invitation

In November of 2006, The Native American Rights Fund (NARF) launched Visions for the Future, the first of what would become an annual art show in Boulder, Colorado. In September, a national call for entries invited Native American artists ages eighteen to thirty-five to submit work that focuses on, celebrates, and highlights the now thirty-seven-year-old mission of NARF. That mission is to defend and exert the rights of Native peoples and to focus on the modern day battles and issues of importance to today's Native Americans and the generations to come, including sovereignty, cultural and spiritual lifeways, tribal lands and natural resources, and Indigenous rights, education, and social justice. By October, more than 130 submissions had been received from young Native artists nationwide.

The goal of the art show was to raise awareness for NARF's work and to bridge generations and communities in the struggle for Native American rights through the celebration of contemporary Native American art and culture. Forty works were exhibited by thirteen young, up-and-coming Native American artists from around the country.

The amount of talent displayed at the Visions for the Future Boulder art show was truly impressive. Many of the young artists exhibited have already begun to make names for themselves in the art world; without question, theirs will be the names to watch for in the near future.

Introduction

Bridging Generations through Art, Culture, Music, and the Struggle for Native American Rights and Justice

The work of the Native American Rights Fund (NARF) to defend tribal sovereignty on behalf of Native Americans has spanned four decades. NARF has served as a pioneer in Indian law and has helped more than 250 Indian tribes and peoples attain landmark victories in the courts. Despite these victories, however, the need to attain justice for Native Americans and resolve historic injustices that still exist today has never been more critical.

In understanding its responsibility, born of more than thirty-seven years of leadership in Native American rights issues, NARF seeks to empower the voices and perspectives of young Native Americans on issues impacting the present and future of Indian Country. Young Native Americans represent the future generations of Native leadership, and they must continue to work to preserve and strengthen tribal sovereignty and Native cultural lifeways. It is also imperative to broaden the level of consciousness and support by non-Native communities regarding major issues impacting Native peoples.

The Visions for the Future art show was symbolic of NARF's commitment to bridge generations, cultures, understanding, and communities through a common commitment to Native rights. The art show brought together contemporary Native

artwork and traditional Native music and culture with modern Native hip-hop. Young emerging leaders were joined by some of the most respected leaders in Indian law to promote a common mission and goal. Featured speakers included NARF executive director John Echohawk; Charles Wilkinson, a distinguished professor; and Moses Lasky, professor of law at the University of Colorado at Boulder.

The juxtaposition of traditional and contemporary facets of modern day Native America and the coming together of generations in the name of Native American rights symbolized the shared understanding of the importance of the work of NARF. It is this understanding and the power of our collective visions that has the ability to unify and enable the continued work to achieve a better and more just future for Native peoples.

The Sovereign Circle

By journalist Jenni Ghahate-Monet (Laguna, Zuni,
Choctaw, Turtle Mountain Chippewa)

*The country had this notion that tribes would disappear, become extinct,
but they never asked the tribes about that. The tribes have fought back
and gotten on their feet, gotten stronger every day.*

—John Echohawk (Pawnee), executive director, Native American Rights Fund

In 1970, the Native American Rights Fund (NARF) was founded through a grant received
from the Ford Foundation by California Indian Legal Services. John Echohawk (Pawnee),
NARF's current executive director, was among its founding attorneys. Through legal
smarts alone, today it represents a foundation that many believe may have supported
more victories for Indian Country than any other indigenous-advocacy organization.

Through a series of sweeping legal successes, the resulting toil has confronted
broken promises and lost lands and deconstructed human rights. Until NARF entered
into the new battleground of courtrooms across the country, treaties were regarded as
nothing more than old, worthless documents. The concept of sovereignty in the greater
public was elusive, at best.

What overshadowed these humble beginnings was the popular conception of
American Indians stuck in extreme poverty and despair.

Indians dwelled at the bottom.

Indians were needy.

Indians were America's poorest of the poor.

Today, a virtual revolution is underway in Indian Country, from New England to the Pacific Coast. For the first time in generations, Natives are shaping their own destinies, largely beyond the control of outsiders, and practicing tribal sovereignty in ways that empower tribal governments far beyond most Americans' imaginations.

Yet in these reinventing times for tribes come great challenges in a new era. The social landscape of Indian Country has shifted into new economies and, in turn, shifted perceptions of Native people based on the wealthy few. In the face of new stereotypes for Natives, the reality is that there is still much work that needs to be done to preserve, protect, and restore the fundamental human and sovereign rights of some of the poorest Indian nations.

Just as in 1970, when lawyers were inspired to pursue work for the neediest of Native people, the push to restore advocacy in a fresh era of obstacles has emerged. A call for cross-generational leadership has mounted to continue protecting what has taken decades to build up and regain. An announcement for action and educational awareness has cultivated a renewed vision for the future.

New Era. New Challenges.

Native America stands strong in the twenty-first century. Today, we are an Indian Country that has evolved into nation building, with advanced, independent governments and sophisticated cabinets of leadership. Through commanded resilience, we have

demonstrated a proud stance in two very different societies—one foot firmly planted in tradition and cultural lifeways, the other adjusted to the greater world around us.

Today's tribes have experienced remarkable rebounds in the last thirty-seven years, brought on largely by court cases involving NARF's legal advocacy. Tribal sovereignties—constantly under siege by the governments, corporations, and individuals—have been buttressed through the law and remain one of NARF's principal focuses. Today's Indian nations have regained recognition at the federal level. Sacred sites have been protected. Water rights have been restored. Tradition and culture has been guarded by allowing Natives to hunt and fish based on customs passed down through the generations. Religious freedoms have been strengthened in our churches and with the proper burial of our ancestors.

There is a new economy for Indian Country that holds great promise. With the advent of nearly twenty years of Indian gaming, education on sovereignty has taken stride. Political persuasion has strengthened in Washington, D.C. There is now a fresh outlook on building alternative wealth, going beyond the casino floor and into progressive markets of sustainable-energy production, corporate ventures, and even global trade.

But with the flourishing of a "Casino Nation," the old idea of Indians has been exchanged with a simplistic new one.

Indians are rich.

Problem solved.

Time to move on.

The reality is that although an altered image of the American Indian is often portrayed in an outline of newfound wealth, there remain many desperate tribal nations grappling with great needs. The truth is that the majority of today's tribes haven't cashed in on casinos; the bulk of Indian Country isn't swimming in slot-machine profits.

Tribal communities, once united in poverty, today face a drastic dichotomy of social-class struggle. Slowly, there is a separation of Natives as they are being divided into a society of the haves and the have-nots. Twenty years ago, this new economy in Indian Country may have been difficult to calculate; most Native leaders then were hardly ever seen wearing tailored suits.

The Indian Wars Never Ended. They Only Changed Venue.

NARF has declared that the Indian Wars never ended, that they merely changed venue. This mission statement has yet to change. After thirty-seven years of providing solid legal representation in local federal courts, and even in the highest court in the land, NARF continues to selectively litigate cases that improve the law, protect Native rights for today's poorest Indian nations, and fight the battles that will strengthen tribal sovereignty.

NARF doesn't take on such classic cases that are at the heart of most private law firms nationwide. When a tribe wants to open a new casino, negotiate with a company over gas rights, or venture into a commercial-fishing hatchery, they don't hire NARF for the legal work. Meanwhile, the other countless cases requesting NARF's legal expertise are reviewed with careful deliberation. Most often, NARF's attorneys select some of the most complicated arguments for some of the neediest tribes and individuals.

It's difficult to imagine anyone but NARF filing the mammoth *Cobell v. Norton* case in 1996. The lawsuit alleges that the trust funds of about 500,000 Indians have been mismanaged by the Bureau of Indian Affairs. Billions of dollars are presumed to be at stake. The case continues to be litigated to this day.

The work of NARF takes almost absurd commitments of time, and it comes at a lofty price. Lawyers often work on cases for decades. The level of legal prowess involved is valued by a quality network of knowledge, resource, and skill. Attorneys also travel constantly from their offices of Colorado, Washington, D.C., and Alaska into greater Indian Country in pursuit of one sovereign cause.

Outside of the courtrooms, NARF has become a leader in education, with one of the most comprehensive Indian-law libraries ever developed. NARF works closely with tribes to improve knowledge of Native rights among today's Indian students. Recently, NARF renewed its commitment to education by pioneering a new movement focused on building strong, healthy alliances with Native leaders of tomorrow. These cross-generational efforts should be regarded as the continued art of justice in Indian Country.

The Art of Justice

When hip-hop music, graphic design, and contemporary art can visually propel a body of work, as seen and celebrated in these pages, therein lies a modern day message for modern day times. In today's digital age of media and technology, a vibrant generational bridge is being constructed, braided together by history, leadership, and education for the future protection of sovereignty and Native rights in Indian Country.

Today there is a demographic of Native professionals and adults who are

children of the very era that marked an age of resurgence for Indian Country. Many were just being born when NARF first began. Others were likely too young to understand the nationally broadcast televised events from Wounded Knee II in 1973. Then there are some who have come to enjoy freedoms and rights perhaps without ever truly grasping the hardships that were fought and won to make life as it is today.

As new challenges in a new era prompt a call for action among today's Natives, the steps needed to meet this goal also call for great education and guidance from one generation to the next. How to best inspire today's abstract youth to react in a manner that inspired a group of attorneys thirty-seven years ago has beckoned a test of age-old methods combined with a new, invigorated style and approach.

The imagery of tribal life in these pages is both contemporary combat and revered allegiance inspired by the legal legacy known as NARF. In a collection of innovative paintings, sketches, and digital art, existing stereotypes are confronted, new perceptions are challenged, and a history of survival is championed.

The black-and-white still photography of Cara McDonald in *We Gather Together* is one example of celebrating today's religious freedoms in Indian Country. The lyrical rhymes of Quese IMC draw expression to our modish identities. Alyssa Macy, through digital photography, reminds us that Native representation is vibrant and strong, even in the urban underground of graffiti art. Meanwhile, the paintings of Bunky Echo-Hawk question our greater placement in these contemporary times.

Dawn Webster, in her mixed-media painting *We Are Here*, similarly celebrates our past, but also declares how our modern day warrior society cannot exist without the constant guidance of those who walked before us. Twinkling stars are metaphors for cultural preservation and a resonating tribute of expression inspired by NARF's legal advocacy.

Nearly forty years have passed since NARF began its mission of standing firm for justice in Native America. Although this movement may appear to have developed at a tortoise's pace, the results evident today are distinguished by an eagle's strength. The fact that Indians have defied the odds of extinction is ardent proof. This point in the greater journey begs for pause, reverence, and support of an organization that remains one of the most established in Indian Country.

The preservation and enforcement of the legal rights of Indian tribes and individuals must continue. Just as it did in the 1970s, it will take a modern day warrior society of the twenty-first century to keep raising conscious awareness of Native American rights and urgent causes.

The inspiration is one that calls on all of us to recognize how we, as Native people, can move forward in our sovereign best, and how we can infuse a responsible fervor in living up to our highest and most self-determined ideals.

The messages taken from this collection encourage the harvest of an emerging generation of Native leaders, visionaries, and advocates in today's Indian Country. Although no single song, painting, or photograph can entirely express what centuries of catastrophe has done to tribes, they can teach everyone who views them about the valiant efforts fought and won, born from an era that has reignited a vision for the future.

In Honor of the Seventh Generation

By *ina* ("mother"), social worker, advocate, and writer
Tara Weber Pretends Eagle (Hunkpapa Lakota)

In our Lakota creation story, White Buffalo Calf Woman brought the sacred pipe to our people in a world where our children and women were sacred and treated as such. Our seven sacred ceremonies were a way of life, and our people were self-sufficient on the land. The buffalo was the spiritual and physical core of the Lakota people's existence. This was during a time when all the Natives could be who they were and live as they wanted, as their ancestors had done for so many thousands of years before them.

We will never know this way of life; neither will the youth of today. The aftereffects of Native American genocide are everlasting. The pain and suffering has been and will continue to be experienced by each generation. Even if we wanted to forget it, we could not. There has been too much damage and too much change. Even the Lakota language was changed when the genocide began. Before that time, there were no words for *immigration, treaty, ownership, money, alcoholic, domestic violence, rape, child molester, adoption, orphan,* or *massacre.* Before that time, Native people weren't dehumanized, humiliated, terrorized by violence, or massacred for speaking their language, for practicing their traditional ways, or for wearing their hair long. Children were not taken from their mothers. No one was ever adopted or given away. No one was homeless. Families were not intentionally destroyed.

The devastation was so that my ancestors' visions told them it was going to take seven generations before any true healing or change could take place. After the

healing began, the languages and traditions would slowly return to our children and they would learn about them with pride and without shame.

Today, this is happening. In the reservation schools, primary Native languages and cultures are being taught as part of school curriculums. Legislation is being established to protect and provide the funding needed to maintain our languages and cultures.

My ancestors knew that future generations would need to assimilate and learn how to balance their lives in both worlds. We would need to become educated as doctors and lawyers who would then have to integrate into the mainstream health care and legal systems in order to better advocate for ourselves. They foresaw the eventual legal accountability that the United States was going to have to take for having committed horrific injustices to our people in the past in order to change the future.

My ancestors envisioned the need for a legal warrior society to represent and protect the Seventh Generation's sacred rights. That legal warrior society is and has been the Native American Rights Fund (NARF).

For the last thirty-seven years, NARF's "briefcase warriors" have honored their ancestors by defending Native American rights in many ways: by developing Indian law; upholding sovereignty; defending natural resources, ceremonial practices, and sacred burial grounds; establishing and maintaining Indian gaming; and holding the United States accountable for what had been deemed necessary at the time.

In March 2007, NARF launched its first ever public service campaign (PSA), The Indian Wars Never Ended, in hopes of reigniting the advocacy fire for the next generation and celebrating its renewed mission of standing firm for justice. The PSA featured NARF's executive director, John Echohawk, and his briefcase warriors in a sixty-second Native hip-hop video with music by award-winning Culture Shock Camp,

which consists of brothers DJ Shock B and Quese IMC, members of the Seminole and Pawnee nations.

This NARF PSA sent a powerful message about sovereignty and what our Native American ancestors went through five hundred years ago, as well as about how the fight still continues today, but now the fight is in the courtroom. The PSA also celebrated and honored music, both hip-hop and traditional, and brought the young and old generations together to not only face the problems of today, but also to heal the past and present with unconditional love and support. In Lakota, this is called a *tiospaye*, a traditional extended family where everyone takes care of, supports, and loves each other unconditionally. In turn, a healthy environment will transpire and the younger generation, the leaders of tomorrow, will be in a position in which their voices are honored and respected.

In yet another example of continuing to honor, empower, and be an example for the Seventh Generation, NARF has created a platform for young, talented Native American artists with this book, *Visions for the Future*. These featured young artists have incredible gifts of strength, an amazing magic touch with paint and brush, and a keen eye for looking through the lens. Their Native American pride can be seen throughout their respective paintings, sketches, and photography.

Despite having the weight of Indian Country on their shoulders, of trying to balance living in two worlds, of facing daily overwhelming, painful realities, these artists continue to preserve and, in the process, have created spectacular artwork. They are modern day warriors. Their ancestors would be very proud.

Alyssa Macy's photographs depict the struggles that Native Americans face when trying to maintain their cultural identity while trying to live in the city after moving away from the reservation. (These Native Americans are known as "urban Indians.")

of graffiti surrounds his head and the rest of the wall. This painting makes one wonder, How long has he been an urban Indian? What is he thinking? What kinds of things does he go through, living in the city? Can he still be a chief if he lives in the city? How different are his issues from Macy's?

In *Writings on the Wall—1492s*, Macy has captured two black, cartoonlike Indian girls with plumes on the backs of their heads and graffiti splattered all around them. Again, this painting seems to be a representation of what so many young Native Americans are facing today—the struggle to find balance and maintain their Native American identity.

Macy's pictures also symbolize the relocation programs that were created by the U.S. government that encouraged Native Americans to move off the reservations and into cities. Oftentimes, many Native Americans moved back home again because the culture shock was just too overwhelming and they wanted to be with their families. To this day, some leave the reservation for a short stay in the city only to return home again. This has been very difficult for the non-Native community to understand, but it is a decision that must be respected and honored, not questioned.

In Daniel McCoy Jr.'s acrylic paintings *Sleeping* and *The Amazing Couch*, he has captured the powerful irony that exists in the lives of the Seventh Generation. *Sleeping* depicts a Native man with long black hair sleeping, and a star and multicolored pastel design in the background, symbolizing visions, the spiritual gifts Native Americans have been blessed with by the Creator. For many generations, Native

Americans have found spiritual peace and guidance in their dreams. McCoy reminds us that sometimes dreams can be a curse, possibly reminding us of our present pain, or showing us pain that is going to be suffered in the future.

The Amazing Couch portrays the devastation of chemical abuse and its everlasting effects. This powerful painting is of a skeleton sitting on the couch, holding a TV remote, and a collage of symbols, words, and pictures over his head that are screaming about the overwhelming, evil impact that drugs and alcohol have on today's Native Americans. You can feel the pain through his painting; it is stingingly powerful. *The Amazing Couch*, unfortunately, is a seemingly unbeatable phenomenon the Seventh Generation is facing today.

From behind the lens, Valerie Norris captured perfectly the spiritual beauty of a Native American powwow with a series of four unforgettable photos featuring modern day warriors, powwow dancing in sync, the wisdom of an elder, and the youth at the drum. Her photos are spiritual, emotional, and show Native pride, and they are empowering and healing for all Native Americans, the young and elderly, to see.

Ogitchida ("Warrior" in Ojibwe) is of a beautiful grass dancer standing proudly in the arbor during Grand Entry at an outdoor powwow. His brown face carries a pondering look, as though he is having a vision as he is surrounded by the honor and strength of traditional warriors with their eagle bustles in tow and by the vibrant pastel colors and silver glitter of the Jingle-dress dancers standing behind him. This photograph perfectly depicts the beauty of the Native American powwow.

Memengwaa Equay ("Butterfly Woman" in Ojibwe) is of a striking fancy-shawl dancer with distinct high cheekbones, jet-black braids, and baby blue and red moccasins. She is dancing in sync with a grass dancer wearing white with multicolored designs with a roach and an eagle feather. Both their arms and knees are lifted in sync

to the heartbeat of Mother Earth, the drum. This is another picture-perfect powwow moment.

Mindimooyenh ("The One Who Holds Things Together" in Ojibwe) is a captivating photo of an elderly Jingle-dress dancer, most likely in her eighties, in her beautiful olive-green Jingle dress and white beaded moccasins. Her many, many years of wisdom are apparent by the brown wrinkles on her forehead and beneath her eyes. Her once-black hair is now pure white and braided in teeny, tiny braids.

This tiny, frail dancer of healing is glancing at the ground, her weathered left hand clutching an olive-colored cloth. One wonders what she was thinking about at that moment. She has seen, heard, and experienced things that are unimaginable to most people. She was born around the time that Native Americans were just given the "right" to be American citizens. I wonder what American citizenship means to her. And what does she think about the American flag as a part of the Grand Entry ceremony? She has paved the path for us in ways that we will never understand. She is an incredible survivor. She dances for her people, a dance of healing and to honor those who came before her. She is a true modern day warrior woman.

Norris's fourth photograph, *Battle River Drum*, is a shot of the top of a youth drum and seven drumsticks being played upon it. The drum is the core existence for Native Americans, as it is the heartbeat of Mother Earth. The drum is the core of the sacred ceremonies and is the sacred way to honor our people, the land, animals, the spirits, and ancestors.

The drum also represents harmony, the one voice of the people. When the lead singer at the drum sings a prayer and sends the prayer to the Creator, the singers repeat that prayer and bring it back down to the people. Ideally, the prayer will make the people of one mind and spirit just at that moment of prayer.

The youth sitting at the drum in the photograph have been taught how important this role is. It is a big commitment and takes a lot of their time. More and more youth are making these commitments and learning the songs so that they, too, can be part of a powwow drum group.

For each nation, the teachings, languages, expressions through artwork, healing, spirituality, innate gifts, strengths—the voice—are very different … very unique. *Visions for the Future* has given these young Native American artists the venue to express their voices and to be heard. It is a blessing from the Creator that these young artists have found their voices and are expressing the daily hardships they are facing in Indian Country. Showcasing their talent in this way is healing for them, and it is educational to others.

This is what their ancestors wanted for them. This is what being Native American is all about.

Mitakuye oyasin ("All my relations")

first warriors on the front line, they took the risk of receiving bullets in the chest and arrows in the back.

As a leading defender of Native American rights today, one faces the same risks. The metaphoric bullets appear in the form of racism, hegemony, colonization, policy, precedence, and plain ignorance. The metaphoric arrows appear in the form of assimilation and colonized mentalities. Today's warriors appear in the form of lawyers, policy makers, educators, writers, and artists. The battlefield appears in the form of courtrooms, Capitol Hill, mass media, classrooms, bookshelves, museums, and galleries. The battle, however, remains the same: defending basic human rights.

Basic human rights are indeed at the core of my art.

Velocity and Trajectory

Contemporary Native American art ceased to be "contemporary" by the end of the nineteenth century. At that time, it was cutting edge and exemplified the multidimensional issues the artist faced. Scenes of war, disease, treaty signings, relocation, and ceremony were depicted as they occurred.

It is my belief that with the introduction of reservation life, boarding schools,

film, and radio, Native American art as a movement was stunted. Artists continue, even in this day and age, to replicate the art of previous generations. Depictions of historical events, attire, and ceremonies became the status quo. Contemporary Native American art suffered from one major bullet, and one major arrow.

The bullet is a large one. Its velocity has ripped through centuries, and its trajectory has ripped through generations of artists. The bullet is colonization. The American public had no interest in the current affairs of Indians and was most comfortable with the notion of the Indian way of life as a thing of the past. The bullet twisted and turned. Mass media, a machine gun, took Indian culture and romanticized it.

The arrow is a sharp one. It, too, has flown through the years and pierced generations of artists. The arrow is assimilation and the acceptance of colonization. Native artists repeatedly replicate the past in art. Even non-Native artists make a decent living from depicting Native Americans as a people of the past.

There was a decent Native American art movement in the 1960s. Artists such as T. C. Cannon and Fritz Scholder threw out the idea of replication. They approached painting through a more contemporary lens. T. C. Cannon explored early reservation life in a visually unique and colorful way. His work became extremely popular and was widely exhibited. His influence has passed down through the years.

This generation of artists, indeed, took a lot of bullets in the chest and arrows in the back. They created opportunities for other contemporary Native artists to follow in their footsteps. They openly contended with historical artists who, in their words, created "Bambi art."

However, to this day, historical, replicated Native American art is still the most widely sought after and created form. When a person learns that I am an artist, predictably they ask if I do beadwork or make pottery. While seeking

representation in various galleries, I've been told that my work is either "too Indian" or "not Indian enough."

Although I fully support an artist's creative path, I long for more artists to create contemporary work. I long to see paintings that tell the stories of today's tribes. I long for that arrow, released from a bow more than 100 years ago, to finally fall.

A New Volley

Indian Country is small. In larger society, it has been said that everybody is related by six degrees of separation. In Indian Country, I would guess that we're all related by two degrees of separation. And because of the nature of U.S. Indian policy, oftentimes what is decided for one tribe affects all tribes. Stereotypes in mass media affect all Indians. Further, statistically speaking, Indians occupy the top of the list in various unflattering categories, including suicide rates, incarceration, and as victims of rape, domestic abuse, and violence. Needless to say, an endless number of issues face Indian Country.

There is also an abundance of ignorance about these issues, both within our communities and in the outside world. Coupled with stereotypes and one-dimensional perceptions of Indians, the lack of education further isolates our communities.

This is where socially relevant art can thrive. It can give artists an opportunity to express their relationship to these issues. Beyond a means to heal, creating socially relevant art can also educate. It not only shows others in the community that other people are experiencing similar circumstances, but it also lends a hand in educating the public. We suddenly become multidimensional in the public eye.

There is also an abundance of Indian organizations, clubs, and businesses. They rely on artists to create logos, brochures, flyers, posters, calendars, annual reports,

and so on. If these organizations are willing to modernize their looks, the artists will create modernized art. Also, if artists are creating modernized art, these organizations and businesses will start using modernized images.

It is possible to indigenize various forms of art. This has been done with painting, writing, sculpture, and weaving. I long for artists to go a step forward and modernize the indigenized forms. For example, in blanket designs, artists are still using icons that were modern 150 years ago. I would love to see an Indian blanket with a biohazard symbol incorporated into it.

I cannot be more disappointed than to know an artist who lives a few miles from a toxic waste site, or who battles with school administrators about the banning of their children's long hair, and then creates paintings that omit these realities. The phrase *contemporary American art* does not conjure up images of pilgrims or settlers. I long for another Native American art movement. I long for communities, businesses, organizations, and artists to take ownership of our own image.

Target Practice

Throughout my art career and professional career, I've had the good fortune of working with some of the nation's Indian organizations. Through doing photography, creating graphic design and T-shirt designs, and by donating art for fund-raising purposes, I've learned a lot about the missions and work of these organizations. I have used what I learned in my art, hoping to educate others and to give our communities a voice.

In most recent years, I created three large bodies of work inspired by socially relevant issues in Indian Country. Gas Mask as Medicine, Weapons of MASS Media, and Living ICONS are the most recent series of my paintings. They have been exhibited

throughout the nation and overseas, in traditional galleries and in museums. I was compelled to look at these issues as targets, and to take target practice with each painting of each series.

Gas Mask as Medicine

This series came about after learning about toxic radioactive waste sites popping up in Indian Country. I felt compelled to share the knowledge of their existence, and to tie in the relationship of biological warfare of past years with the construction of these sites, which typically target Indian reservations. I wanted the message to be strong, undeniable, and memorable. I wanted people to think about it, to ask questions. So I used the image and idea of the gas mask.

The gas mask is a very formidable image. It conjures up memories of past wars and perhaps, very tangibly, thoughts of impending wars. The gas mask image bridges the gaps between wars, the present, and the future. Although it is a symbol of war and a targeted nation, it is also one of preparation, organization, and survival.

The gas mask, when worn by Native Americans, signifies several other subjects. It is a reference to the Native American demographic collapse, or Holocaust, due largely to primitive colonial means of biological and germ warfare. In 1539, Hernando de Soto invaded Florida. He brought two hundred horses, six hundred soldiers, and three hundred pigs. The swine carried and spread anthrax, brucellosis, leptospirosis, trichinosis, and tuberculosis. Forests were contaminated, which in turn contaminated native animals, and consequently killed at least 200,000 Native Americans. In 1763, Lord Jeffrey Amherst ordered smallpox-infested blankets to be dispersed among the Ottawa as "gifts," so that "we may extirpate this execrable race."

This has long been the government's attitude toward Native Americans.

In recent years, the U.S. government has been using the Native American population as guinea pigs. In Washington State, for example, the Hanford Nuclear Reservation waste, weapons, and research facility performed a secret experiment in 1945. Hanford released nuclear waste into the environment onto nearby Yakama and Spokane reservations. The total amount of nuclear waste released is estimated to be ten times greater than the quantity released from the Chernobyl meltdown in 1986.

The images in this series are bold and contemporary. The gas masks are juxtaposed with traditional clothing, exemplifying the dualities of contemporary Native American life, the perseverance of culture and religion through hardships, and the stark reality that we have survived.

In 2003, the Native American Rights Fund (NARF) featured several paintings from this series in their annual report. It was an opportunity to reach a large group of people with my art. It was amazing, and very humbling, to see these paintings in print alongside NARF's case updates.

Weapons of MASS Media

In this series, I chose to take aim at the way mass media has shaped the perception of Native Americans for both Indians and non-Indians. Mass media has long been a weapon of mass destruction for Native Americans. In 1456, Johannes Gutenberg invented the printing press, which enabled the mass production of literature. This invention, credited for spurring intellectual growth at the end of the Middle Ages and spawning an era of enlightenment, not only devalued the spoken word, but allowed for the mass production of Bibles, which has been detrimental to indigenous

societies worldwide.

Mass media was used early on in American history to garner widespread public support for, and to justify, the violent occupation of this land and policies encouraging the extermination of Native American people and culture. A fistfight between an Indian and a white in California would read as a bloody massacre by the time the story reached New York newspapers. Ads were placed in newspapers offering ten cents for Indian scalps or notifying the public that Indian land was "for sale."

Today, mass media hurts Native American culture in two ways. First, negative stereotypes are repeated in all forms of mass media. In television, movies, books, art, newspaper editorials, and so on, more often than not, the perpetuation of Native Americans as a people of the past prevails. Further, negative contemporary stereotypes are also present, such as alcoholism, casino greed, and sports mascots. Second, the blatant absence of a true Native representation in mass media is also disadvantageous, as it reinforces the notion that Native peoples are no longer among the population.

The paintings in this series use mass media as a vehicle; the images are identifiable as American cultural icons and convey a message that is both palatable and subtly challenging. In some paintings, the subject is depicted at face value—a reproduction of a racist advertisement, for instance. Other paintings contain non-Indian icons that are rendered in Indian style, encouraging the audience to consider a Native perspective as a parallel and an alternative to the assumed reality of the American icon.

In this way, I am using mass media against itself. Ironically, this series is popular in some forms of mass media. A lot of the paintings have been featured in various publications, such as *Red Ink* and *Heritage* magazines. Electronic images of the paintings are also widely used on the Internet on sites such as MySpace.com.

I was at the Santa Fe Indian Market in 2006, amidst 1,000 Native American

artists. Although I was not "set up" at a booth, I was there supporting the fund-raising efforts of NARF and the American Indian College Fund. I was visiting with an old friend from college (we both attended the Institute of American Indian Arts at the same time) when her cell phone started beeping. She opened it, and began laughing. She had just received a multimedia text message. It featured one of my paintings, with some text I can't remember and a round-dance song. I found it ironic that we were surrounded by rugs, pots, and replicated art, and my own art was making an appearance in a functional way that people could relate to.

Living ICONS

This series of paintings was partially inspired by the Native American Rights Fund's public education campaign slogan "The Indian Wars Never Ended." The Indian wars never did end. The battlefield is just more abstract now and sprawls through every facet of our lives. We are still fighting to retain our basic human rights, keep our land, restore our languages and religions, and maintain our identity. Our ancestors may have lost the battle against colonization, but we continue to fight against its effects.

In Living ICONS, I chose to illustrate some of our living leaders, artists, and innovators for a number of reasons. The first reason is that, as a whole, people conjure up names of leaders who lived 150 years ago when asked to name notable Native Americans. Coincidentally, 150 years ago, killing Indians was public policy. It's damaging that the most accepted contemporary view of Native Americans is from this era, and that speaks volumes about the American collective mentality.

Further, I've noticed that a lot of Native people today subscribe to that view. They will either embrace our ancestral war heroes as role models or completely

embrace the mainstream American culture. The minimal regard for our leaders today also comes with heavy criticism: often, if one becomes successful, he or she is labeled as a sellout.

Finally, the people I chose as subjects are people I admire for their leadership, innovation, success, and their role in combating colonialism in their own ways. I aim to shift the mirror a bit to reflect our society and culture in a contemporary light. Perhaps 150 years from now, these individuals will be mentioned as notable heroes. In the meantime, they will occupy some canvas and continue the good fight.

War Cry

Throughout my career, I have received more bullets in the chest than arrows in the back. It is my hope that more artists will take up arms and address change through socially relevant art. It is my dream that future generations of artists will not only be able to make socially relevant art, but that the subject matters of their work will be less grim. I am optimistic about this movement, as there are already great modern day warriors leading the way. We just need to follow them—and aim just above their shoulders.

Culture Shock Camp

Culture Shock Camp, comprised of Marcus "Quese IMC" Frejo and Brian "DJ Shock B" Frejo, is an all-Native hip-hop group from Oklahoma City. Culture Shock's sound and vibe is defined by its unique and powerful blend of hip-hop and Native music that promotes a message of wellness, unity, and Native pride. Culture Shock was named "one of the most celebrated hip-hop groups in the Native American world" by *The Source* magazine, one of the largest-selling hip-hop magazines in the country.

Culture Shock Camp has a cutting-edge style that enables them to take audiences on a unique cultural journey during each performance. Culture Shock's dynamic sound, combined with the powerful and positive message they convey through music, words, and dance, leaves a lasting impact on audiences, particularly on Native youth.

In many ways, the music of Quese IMC and Culture Shock Camp is representative of the emerging voices, worldview, sensibilities, and complex makeup of identity of today's generations of young Native Americans. Quese IMC and the group's conscious brand of hip-hop reveals a deep understanding of the history of Native Americans and a cultural awareness of the Frejos' Pawnee and Seminole languages and teachings in particular. Culture Shock also conveys a lyrical and conscious call not only to young Native Americans, but to older generations as well to unite and work together to bring about healing, reconciliation, and positive social change to promote an era of regeneration and revitalization of Native cultural and spiritual lifeways and the health and sustainability of Native nations.

Culture Shock's unique message is appealing and accessible to all generations,

Native and non-Native, and has led a unique and exciting partnership between the hip-hop group and the Native American Rights Fund. Quese IMC and Culture Shock Camp will promote NARF, its mission, and ongoing work on behalf of Native peoples through its music, concerts, youth development work, and special events.

NARF Affected My Expression through Hip-Hop

The Creator gives us all gifts and talents that we choose to use. Fortunately for me, I chose to use mine, and it feels good, not only because I have the opportunity to reach so many people through my words and music, but also to translate social issues to people who may never have had the opportunity to have such information.

I have always loved hip-hop and the art of making music, producing, and writing lyrics. Recently I came across the Native American Rights Fund. I've always known that music brought me happiness and that helping my people was my reward, but now I've related spiritually to the new meaning of knowledge: education. I have come to find an interest to further my education because of NARF's parallel efforts to bring awareness to our Native and non-Native people about Native American rights and the protection of our sacred sovereignty. Through the medium of hip-hop and beats and rhymes with Indigenous roots, I am the answer to my ancestors' prayers.

Herre mahe momet herkv apeyakvres, emunkvt omvres merretv. Turahe.

—Marcus "Quese IMC" Frejo

Song

A Summer Dream

From my birth/ to the Earth/ Mother Earth now it's time you can breathe/ until the day I leave this Earth and am received beyond the great divide/ I will lead a trail for those yet to come/ none left undone/ I believe from our laughs to grieves we'll be the blessed ones/ I will say it how it is/ to everyone at a thousand gigs/ to nonnatives and the nations, urban, traditional, and powwow kids/ Everyone/ women, elder, mother, father, and son/ and even if it bothers some/ and people think I'm on one?/ I am./ Running a race for my race/ so they can realize their rightful place/ and embrace/ their identity/ that for a century was misplaced/ Colonization/ on all the nations on a scale full-blown/ taking three-year-olds/ away from home/ and brainwashing them 'til they were grown/ Mom and Dad kept the braids/ daughter and son left the ways/ through the cultural genocide/ or our identity and pride/ we're left to stray/ From the buffalo to the boarding schools/ Being free to the blood pools/ to physical abuse from the church priests and nuns, cordial rules/ It was physical, mental, sexual, and emotional/ Through this we cried an ocean full/ of tears that was suppose to pull/ The native from our minds but our BLOOD they couldn't clear it/ you see their missions were a failure because they couldn't kill our spirit/ and we're alive/ we survived/ even though it wasn't televised/ five hundred years they couldn't break us/ we look through these same eyes/ War heroes, heroes unsung, were you there?/ You can still hear their war cries, resonate through the air ...

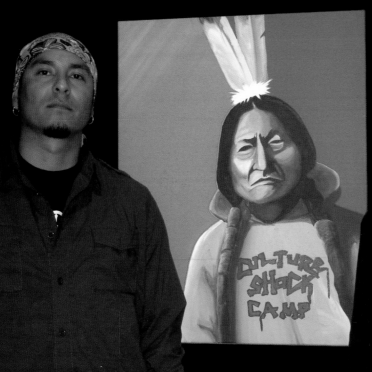

through this breath of mine/ I take this death of pride/ that was oppressed upon my people to question the mind/ because we're left to rise/ I will rise, you will rise/ either in life or death and death of minds/ no more endless lies/ an broken treaties and friendless hi's ... (Repeat)

I'm a warrior with war paint/ and a microphone as the cord hangs/ talking about your state/ your ways/ church and state/ being every way the LORD ain't/ Lord wait/ how could a people/ who bore rape/ and talk about God's love have more hate/ Our words were sacred, like *friend*/ the shake of a genuine hand/ but their promises were like blank word absurd, vicious, and bland/ Hey, Mr. Missionary Man/ interested in/ saving the souls/ of my sisters and bros/ and next of kin/ please tell me if it's genuine/ I'm NVISIONing a plan/ of an infinite stand/ of many or by myself, a spiritual movement transformed into a man/ and why were they sent to this land?/ Manifest Destiny/ an Indian man less than than the/ dominant society infiltrated aggressively/ I say this collectively/ with collected information respectively/ with corrected history/ from my people on the reservation to the big city/ Our struggle etched in eyes/ ancestral ties/ with American history/ left with lies/ we're left with a history that went unrecognized ...

(Chorus)

Look around, look around tell me what you see what you found/ are you down to stick around/ and bound by the Herr Hvliswv Hesakvtemese/ Hofonvn yvmvt follet/ yo the time is close/ Let's have a toast/ and in that I say "espoketit om kerreskos"/ This might be the last time/ so in my rhyme/ I say "Turahe"/ Quese go all the way/ No one can stop you when the mic is on and the venue is packed/ Everything is okay, I'm relaxed I'm not worried about whom I'll attack/ I just want the mic with the speakers and I'm rockin' through the track/ Give me some water and some juice/ I'm the engine/ and the caboose/ the beginning of the end of my existence between the spirit of the truth/ I'm living life I'm living large/ without the cash and flashy cars/ without bellying up at bars/ with scars/ drowned in sorrows and seein stars/ Life is hard/ hardworking/ working hard/ searching far/ for success in life/ but in that, know who you are/ Sing moms raising sons and daughters/ fathers becoming martyrs/ and together build that circle and charter it forever ...

(Chorus)

Written by Marcus "Quese Imc" Little Eagle,

Makvsee Music, LLC

TURE

During Visions for the Future, artist Bunky Echo-Hawk did a live performance that riveted art-show goers as they watched him create an acrylic-on-canvas painting. A large crowd surrounded Echo-Hawk as he painted while Culture Shock Camp performed hip-hop. After the painting was finished, it was auctioned off to the highest bidder, with proceeds benefiting the Native American Rights Fund. With an evening of amazing art, music, and culture dedicated to Native rights and NARF, the art show proved to be a feast for the senses for all who were present.

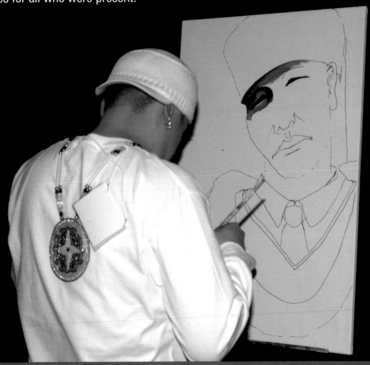

I was born and raised in Denver, Colorado. My roots go back to the Skarure Kahetenu'aka (Tuscarora—People of the Cypress) and Tsalagi (Cherokee) people of North Carolina. I have been drawing and painting since childhood. My father is an artist, as was my grandfather, so art is in my blood. I am very active in the local Native community. I enjoy attending powwows and other Native events as well as volunteering for various Native organizations. In addition to creating art, I enjoy reading and writing. My artwork has appeared in *Red Ink* magazine, and my articles have appeared in *Seventh Native American Generation*, *Pacific News Service*, *Youth Outlook*, and the *San Francisco Gate*. I've been quoted in the *Boulder Daily Camera*, the *Associated Press*, and *Indian Country Today*. I use both my writing and my art to address issues in the Indigenous community.

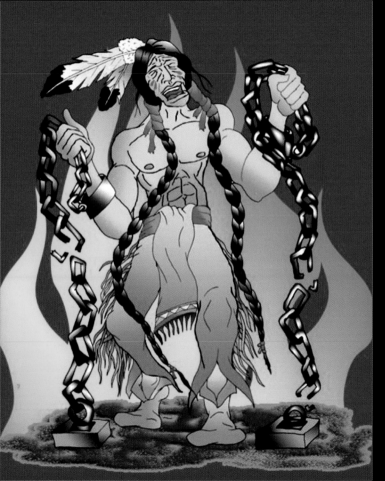

Broken Chains

Pen-and-ink line art and Photoshop digital illustration, 9 x 12 in.

This one is a little "comic-book style," but it conveys a powerful message of Indigenous resistance and perseverance. The fire behind the figure could be the "fire" of resistance, while the chains are whatever holds Indigenous people down. The figure dramatically breaks the chains of oppression.

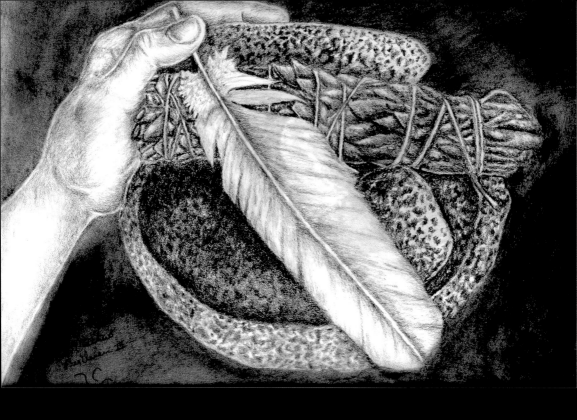

Sage Bundle Graphite on drawing paper, 14 x 17 in.

I think we've all seen traditional still-life paintings—they are often bright and colorful, usually of a bowl of fruit or something. That's not exactly my style, so I decided to do a different take on the still life. This black-and-white graphite on paper is a drawing of a stone bowl I use for smudging with a sage bundle and hawk feather.

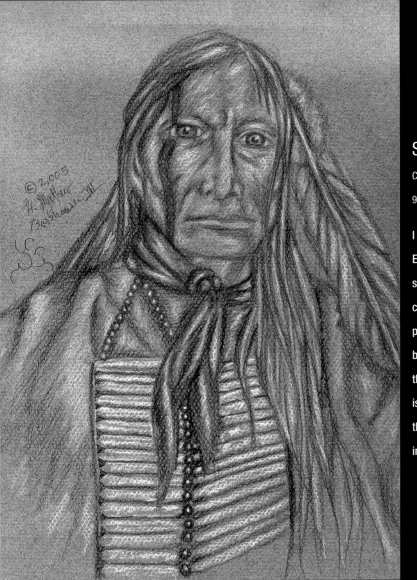

Stoic

Charcoal on tinted paper,
9 x 12 in.

I was flipping through a book of Edward S. Curtis photographs and saw a face with some powerful characteristics, especially the piercing eyes. This portrait is loosely based on that photograph. Although the "stoicism" of American Indians is somewhat stereotypical, I think this image evokes a sense of pride in Indigenous heritage.

Duane Dudley

(Choctaw)

I was born in Talihina, Oklahoma, in 1973. I am the youngest of three children, and we were raised with my grandparents as well as my great-grandparents. There has always been some sort of artist in my family; however, we never considered ourselves artists. Art was just something that you did to express yourself. So far, I am the only one who is going to school for art. I want to expose different types of art to Native people and encourage others to go on to university.

The subject matters I depict are from real events that I have encountered. I somehow find myself recording history while it is being made. When people are moved by my pieces, I feel that I have succeeded as an artist. It's funny to hear them say, "I have been there" or "That looks like someone I know." Sometimes I just get a calm silence. That is okay, too, because I feel as if I have provoked some thought.

Did You See the Game? Pastel, 16 x 22 in.

This was one of my first pieces. The pastel drawing depicts two men laughing during a Native American Church ceremony. The scene breaks away from the stoic, surreal stereotype with which Native Americans are often labeled. This scene shows the viewer that Native people are capable of humor during what would appear to be a serious circumstance.

Sovereign Note Pen and ink, 28.5 x 19.5 in.

The inspiration for this piece came from the lack of recognition that Native people are subjected to. I had to really think about what the focal point was going to be, as the United States reserves this place of honor for a president. It just seemed fitting to recount my Choctaw people going to a stickball game during a time when we had no concept of money. How ironic is that?

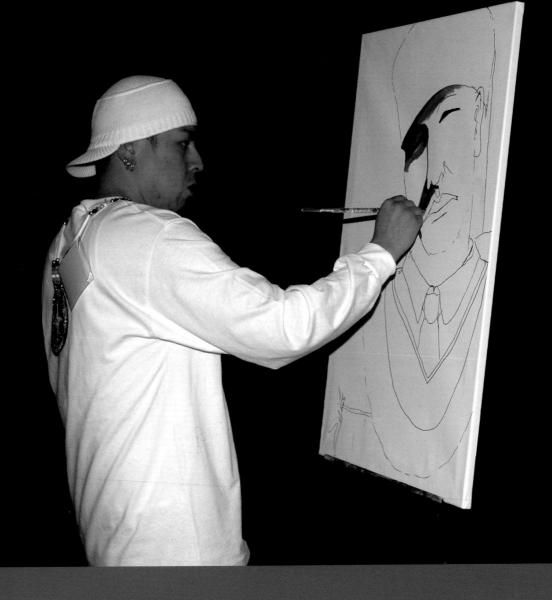

duality of the two worlds and the juxtaposition of culture and identity. This is where my art has originated from: the pursuit of a true identity and the need to share this identity with the world.

It is my duty as a Native American artist to truly exemplify the current state of Native America.

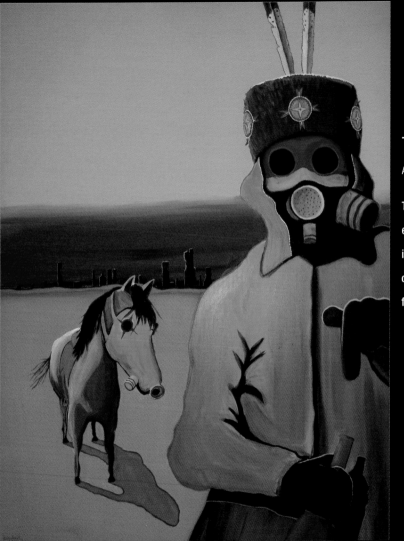

Tribal Law

Acrylic on canvas, 3 x 4 ft.

This is my vision of tribal law enforcement in the future. If the future is the destination of the path we are currently on, there will be a dire need for protection of our culture.

Camp Crier

Acrylic on canvas, 3 x 4 ft.

Republicans and Democrats accuse each other of controlling the media and having a political bias when broadcasting the news. I think it would be interesting to see a national news program broadcast from the Native American perspective.

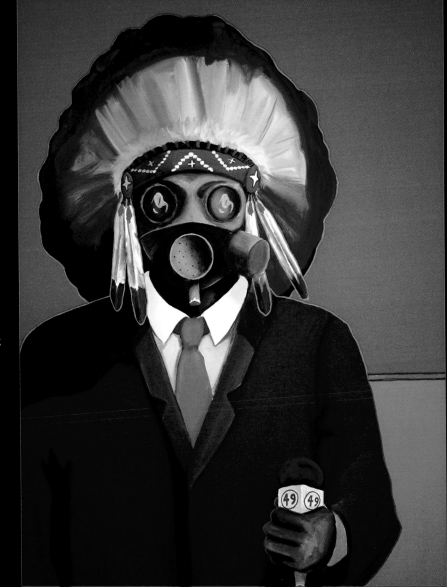

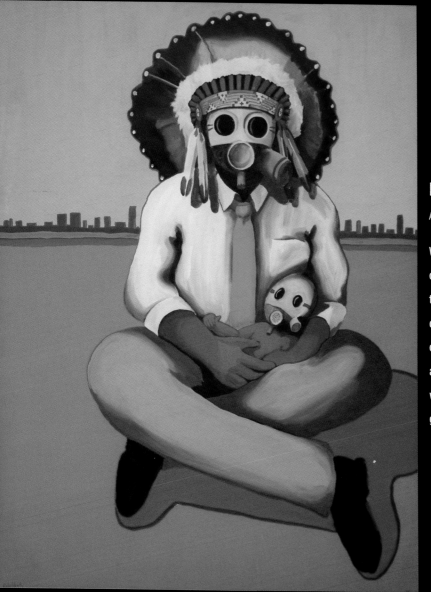

Inheriting the Legacy

Acrylic on canvas, 3 x 4 ft.

When people die, they keep on dying, piece by piece, until the events of their lives have concluded; yet that which lives on is their legend, precedence, and tradition. I often wonder what I will leave behind for my grandchildren's children.

Nadya Kwandibens

(Ojibwe)

I am Ojibwe (Anishinabe) and hail from the Northwest Angle Number Thirty-Seven First Nation in Ontario, Canada. I am a photographer who was first introduced to the art while enrolled in the film program at Confederation College in Thunder Bay, Ontario.

After buying my first camera, in 2004, I began to see photography not only as a tool to document experiences, but also as a fulfilling creative outlet. A move to Arizona in 2005 only deepened my passion for the craft and strengthened my skill in nature and still-life photography.

Photography, for me, is about living in the moment, completely and with all my heart. You won't hear me talk about the technical details of the craft. You will hear me talk about people and about places, about moments of cinematic beauty in the most common of places. At times it can be hard to see our surroundings as beautiful, but there are moments of cinematic beauty that happen every day. When we recognize and acknowledge these moments, it can uplift the spirit. By our own volition, we can acknowledge the potential for spirituality in our lives.

Knot Here Digital photograph, 1 x 1 ft.

William Lewis

(Dine)

I was born in Salt Lake City, Utah. I started drawing at the age of seven because of my dad's influence. I grew up watching him paint canvases and using watercolors. I am an artist with a family. My style of art started developing during my freshman year of high school. The form of my art is influenced by hip-hop culture mixed with Indigenous culture. The mediums I use are watercolors, paint markers, ink, and spray paint. My art represents modern day hieroglyphics with one of the elements of hip-hop culture, graffiti art.

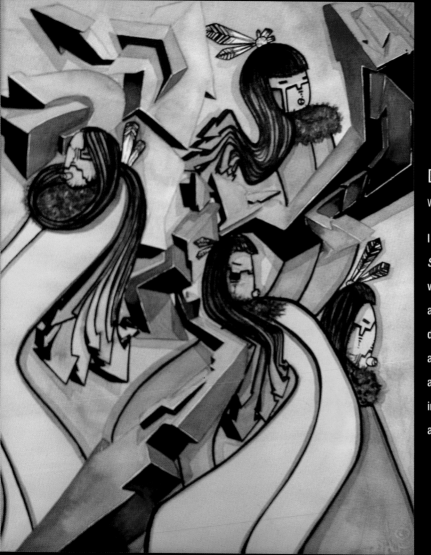

Dine Four Spirits

Watercolor and mixed medium, 2 x 3 ft.

I was inspired to paint *Dine Four Spirits* from my memories of watching our traditional dances as a boy. The images of the dancers came back to me one day and I wanted to paint them from a modern perspective, therefore I incorporated elements of graffiti art into the painting.

Confederated Tribes of Warm Springs, Oregon. I spent the first eighteen years of my life on the Warm Springs Indian Reservation. Early on, I was exposed to issues of American Indian sovereignty, justice, morality, and mutual cultural respect through my parents, who were involved with the American Indian Movement. Their work to right the gross injustices suffered by American Indian people has instilled in me the conviction to do the same.

Through my own participation in the global Indigenous movement and hip-hop culture, I have many opportunities to document the struggles of my people and the evolving hip-hop culture at the grassroots and global levels. My goal is to capture images that not only tell a story, but that move people to action. I consider the world my studio, and my camera seldom leaves my side.

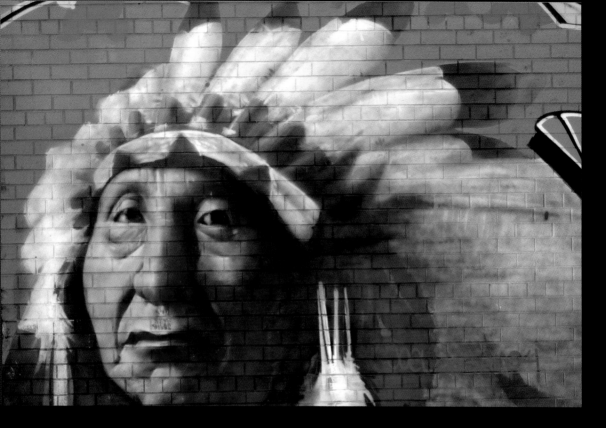

Our Past Must Guide Our Future

New York, New York, Photograph, 8 x 10 in.

I met the eyes of this elder during a walk through Brooklyn. My camera and I were not having much luck that day in finding things to shoot when I rounded a corner down near the river and saw this piece. Judging from the date on the mural, it's been around for many years and—despite the graffiti-crew wars—has never been defaced. A testament, in my opinion, to the strength and beauty of our cultures. I hope it's around for a long time.

Writings on the Wall—1492s

Minneapolis, Minnesota, Photograph, 8 x 10 in.

I came across this piece underneath a bridge in Minneapolis a few years ago. From that point forward, I was constantly searching for the *1492s* and was determined to find out who created them. Every time I came across one of them, I was ecstatic. It was like finding a long-lost relative. I eventually did meet the artist and, as I suspected, he is Native. I've maintained a friendship with him—pulled him into some projects that I've been involved in—and continue to support his development as an artist. I think he's got something!

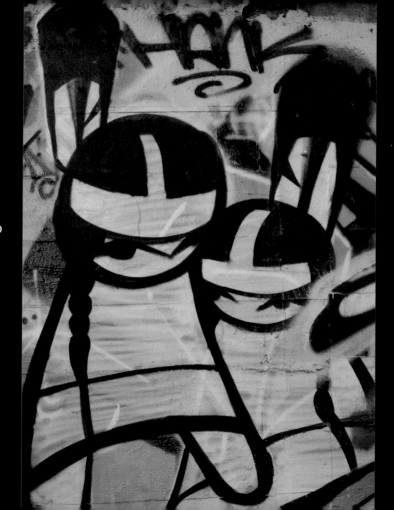

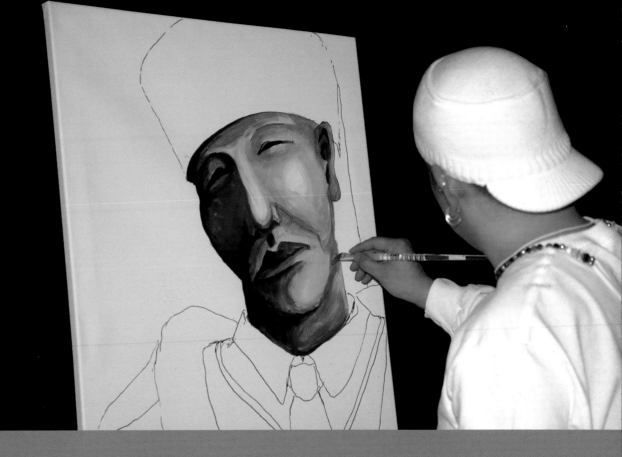

Daniel McCoy Jr.

(Muscogee Creek/Potawotami)

In the paintings I have done in the last few years, I seem to address the thoughts, themes, and problems of the here and now. It is impossible to live in today's society as our ancestors lived, and maybe that is from where I draw a lot of my inspiration—I have not completely assimilated, but I do have a microwave in my kitchen. So I tell my stories in these paintings, trying to reveal something to all people, while at the same time trying to uncover something for myself. My goal is to create a visual time line of this short, beautiful life—something that, hopefully, will outlive me.

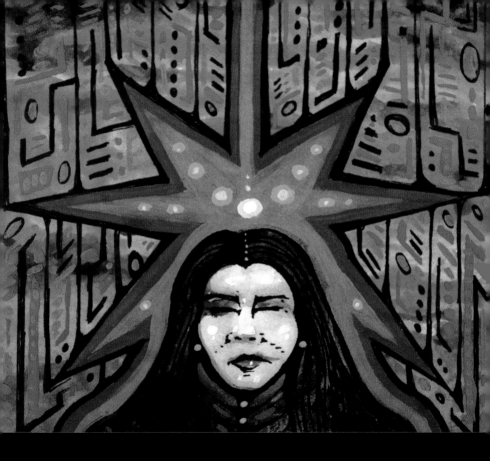

Sleeping Watercolor, acrylic, and ink on paper, 5 x 5 in.

Upon moving back to Oklahoma in 2004, I did a series of small experimental portraits on paper using watercolor, acrylic, and ink. Each piece measured five by five inches. The series was sort of spontaneous creativity. Before starting this piece, I thought about how lucky we are to have dreams during sleep—though sometimes I suppose that can also be a curse. This one celebrates the importance of dreams and visions to Native peoples.

The Amazing Couch

Acrylic and metallic paint on canvas,
50 x 72 in.

I worked on this painting for about three months, but I've had it in my mind for about fourteen years. It deals with modern day struggles that happen everywhere. I paint about all of us who have been hurt somehow by chemical abuse. Sadly, it's a phenomenon among Native families. This painting forces us to look at the vicious cycle of drug and alcohol abuse. It's happening tonight in Native America … everywhere.

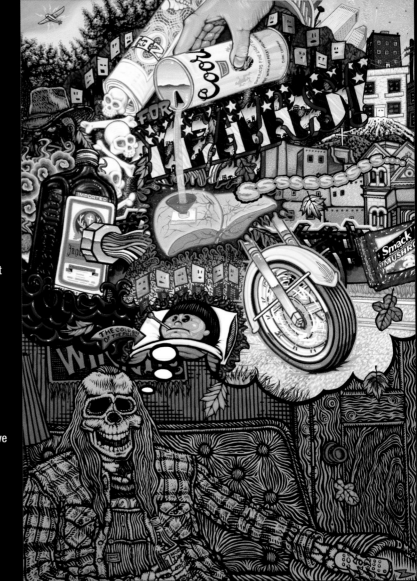

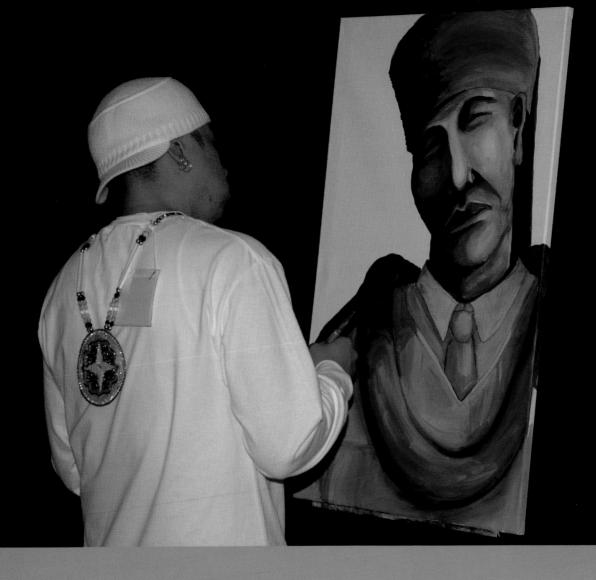

Cara McDonald

(Chemehuevi)

It all started in a double-wide on the Rez. Eight of us and a dog.
No HUD houses. No city lights. No paved roads. Just the Mojave Desert
and the Colorado River that runs through her. I am Chemehuevi. We
call ourselves *Nuwu*, "The People." As it was in the beginning. As long
as anyone can remember. This is my place in the universe. This is how
I see the world. Not like other people. Not like other artists. I feel.

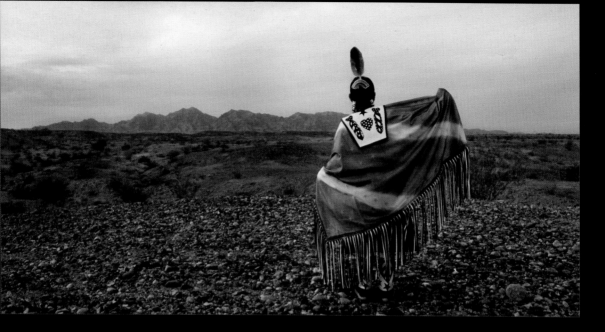

Pan-Indian Movement Photograph, 16 x 20 in.

This photograph is of a panoramic view of the Chemehuevi Mountains, the Mojave Desert, and a young Chemehuevi shawl dancer. As photographed, this landscape no longer exists; it is now under development. This picture portrays a sacred dance at a sacred site. It is about spiritual lifeways and protection of our natural resources and sacred sites. *Pan-Indian* refers to both the panoramic view and the spread of powwow culture, and *movement* refers to both the shawl dance and the revitalization of our culture.

We Gather Together

Photograph, 16 x 20 in.

The Native American Church and the religious freedom it symbolizes is the subject of this photograph. This was taken at sunset, before a ceremony. The sunburst behind these strong silhouettes brings drama to how the Native American Church embraces spiritual lifeways.

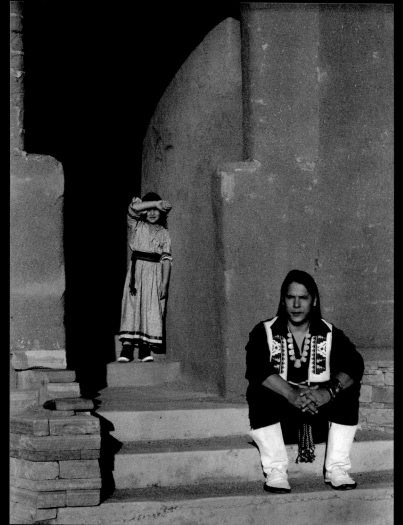

Basket of Cactus Flowers

Photograph, 16 x 20 in.

This photograph is of Mateo Romero and his daughter, Jo Povi, which means "basket of cactus flowers" in Tewa. There are many reasons why Mateo is a modern day warrior. While I was attending the Institute of American Indian Arts, Mateo taught me drawing and printmaking. He is a master contemporary painter and, among many other achievements, a graduate of Dartmouth College. He is an extraordinary Native American educator and purveyor of the health, culture, and well-being of the Pueblos. Mateo is a role model for Native American fathers and young warriors.

Valerie Norris

(Red Lake Nation)

For me, art has always been the simplest and purest way of communication. While photographing, I let the moment guide me. I love to catch glimpses of hope, wonder, strength, and beauty in my prints. My photographs are not a part of me, but rather an extension of me and you.

People ask why I'm photographing. I tell them it is because I cannot live without it. It gives me freedom. When I have the camera in my hands, I lose track of time. I prefer to produce art that captures diversity in everyday objects and people. There is a whole new world right before your eyes, and most people cannot see it; they are too busy just keeping up with life. I want to remind them of the magic of tiny moments and to not forget them, because this is what life is about—seeing through new eyes every day.

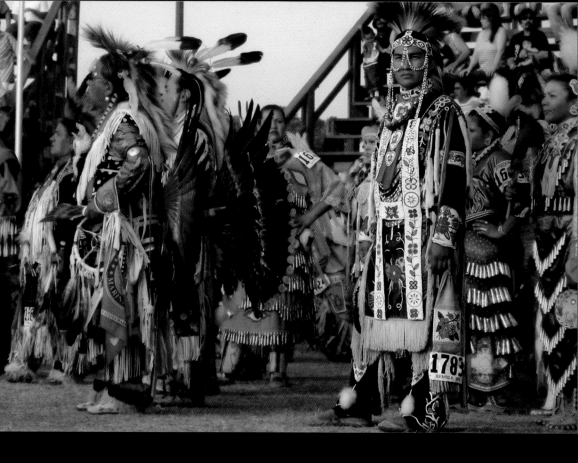

Ogitchida (Warrior) Digital photography, 8 x 11 in.

This one small moment captured a modern day warrior in traditional Anishinabe floral beadwork at the Red Lake Nation Independence Day powwow. The powwow celebrates the tribal chiefs and their resistance to allotment during the negotiation of the 1889 Nelson Act. Red Lake Nation is one of only two reservations in the United States with sovereign nation status. A powwow is a place to visit, sing, drum, and dance.

Memengwaa Equay
(Butterfly Woman)

Digital photography, 11 x 16 in.

Genocide, ethnocide, racism, rape,
oppression, colonization, Christianization,
structural violence—these are harsh
words to describe our history and even
our present-day reality, but look and see
the grace and strength of Indigenous
women today. We are revolutionaries
of resilience. It's a beautiful thing. We
are strong.

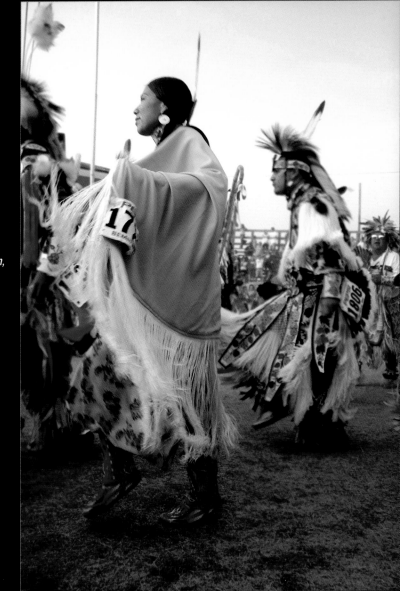

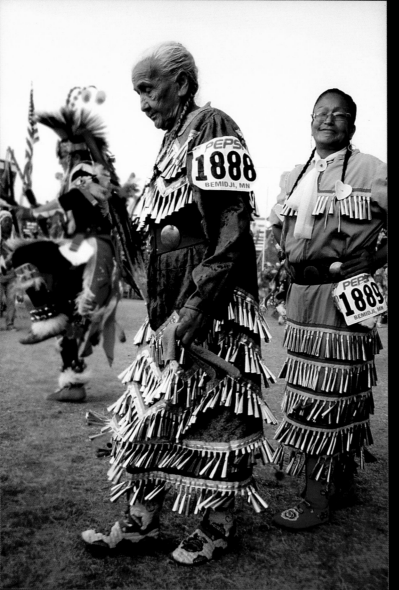

Mindimooyenh (The One Who Holds Things Together)

Digital photography, 11 x 16 in.

Mindimooyenh in the Ojibwe language means "an elderly woman," but it is translated as "the one who holds things together." The women are the backbone of the family, of the community. The Jingle dress is a healing dress, and its origin stems from the Anishinabe. She dances to heal.

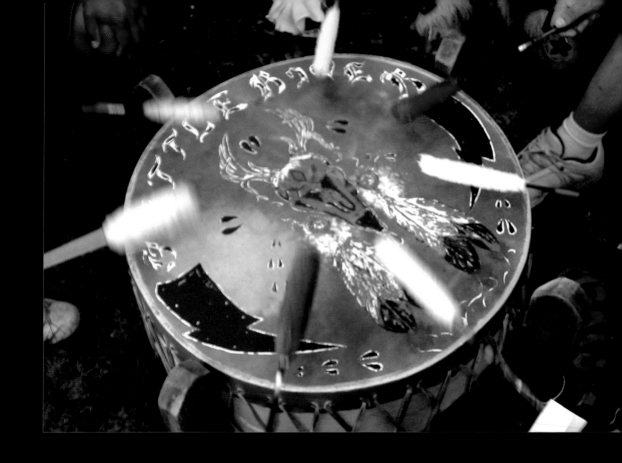

Battle River Drum Digital photography, 8 x 11 in.

The drum is powerful in its beat. It is the heartbeat of the nations. It is alive with spirit. The wisdom and strength heard inside the beat of the drum is evidence of a culture and people that have survived great obstacles the past several hundred years. You can hear the depth in the singing voices and the drumbeat. It is centuries old but not tired or worn. We are still here.

Victor Pascual

(Navajo)

I am from the Navajo Nation. I was born in Shiprock, New Mexico, and grew up in Farmington, New Mexico. I graduated college in 2005 with an emphasis in graphic design and a minor in art history. I now live in Seattle, Washington, working as a graphic designer for a small design firm.

I create works of art in the digital form that are inspired by my own people and our struggles as an Indigenous population in today's postcolonial society. In my work I try to express the impact modern Western technology has had on Native America and its frequent use by some of today's youngest and most talented Native artists.

Navajo Trademark

Digital print, 18 x 24 in.

This piece focuses on my tribe. It seems that today there are many Navajo people in and around every major city you might visit. From the elderly to the college student, we are everywhere. And with that, it seems that the name *Navajo* has been used in many different ways—from retail products to high-school cheerleading teams.

{ i am native }

I Am Native

Digital print, 18 x 24 in.

This piece focuses on identity, but in a subtle context. This piece can be interpreted in many different ways and from different perspectives, whether from being an Indian from the reservations or from the cities. Identity is an important part of who we are, and preserving that has become a part of our struggles and lives.

Thomas Ryan Red Corn

(Osage)

ZHA.ZHE WI.TA WA.KOn.T'I.A. TAn.WA LAn WI.TA TSI.SHO WA.SHTA.KE. WA.ZHA.ZHI MIn.KSHE. Art is a weapon. It has skewed identity in some communities beyond recognition. It has swayed public opinion and wreaked havoc on the front lines of every battle fought this century. My art serves to assert control over one of the most sacred sights, the one between your ears. My art is about pride. It's about telling stories that have not been told. It's about reclaiming visual space. It's about Indigenizing all forms of mass media. It's about speaking your language. It's about going back home. It's about fulfilling your obligation to your community. It's about dancing. It's about singing. It's about listening. It's about resisting. It's about the language of power versus the power of language. It's about making our presence known, and it's about making the world meet us on our terms.

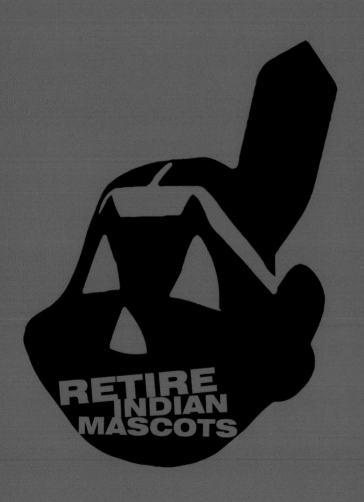

Retire Indian Mascots

Hand silk-screened poster,
18 x 24 in.

American Indian mascots are plaguing our nation's sports teams. At all levels, from elementary schools, high schools, universities, to national sports franchises, the use of Native mascots is historical residue of an era that witnessed the death of all other publicly displayed racially slanderous imagery except the "Indian" mascots. Let's see these images go the way of Little Black Sambo and the Frito Bandito.

Insurgents

Hand silk-screened poster,

18 x 24 in.

This poster makes use of a
commonly used term to define
those who fight the United
States in conflicts across the
globe. Its purpose is to put
into a historical context the
use of that word and what
is understood about those
individuals who get labeled
as insurgents.

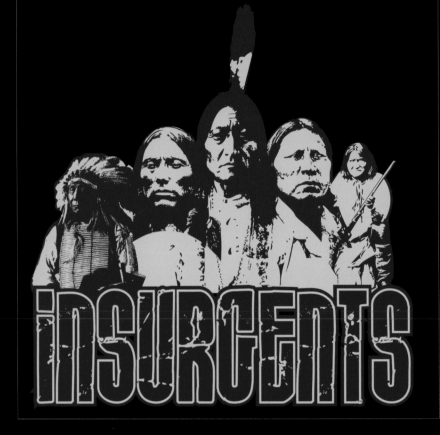

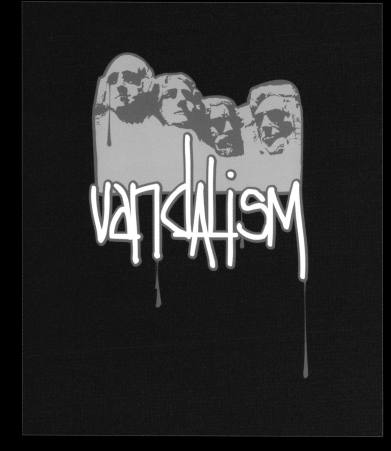

Vandalism

Hand silk-screened poster, 18 x 24 in.

The Black Hills were never sold to the United States and are sacred to the Lakota. Seeing these "founding fathers" in this place is heartbreaking. Natives knew Washington as "Town Destroyer." Jefferson started the policy of marching Natives west, which led to almost every tribe's "Trail of Tears." Lincoln holds the gallows world record for simultaneously executing thirty-eight Santee Indians in Mankato, Minnesota. Theodore Roosevelt used his executive authority to take millions of acres from Indian reservations to be made into national parks without a single treaty being signed. Monuments are relative.

Hidden Voices, Coded Words

Hand silk-screened poster, 12 x 18 in.

This poster was created in commemoration of the men who served in the United States' military during World Wars I and II as Native-language code talkers from Oklahoma. Their service saved hundreds of thousands of American lives. This poster tells their story. And it tells it in their language.

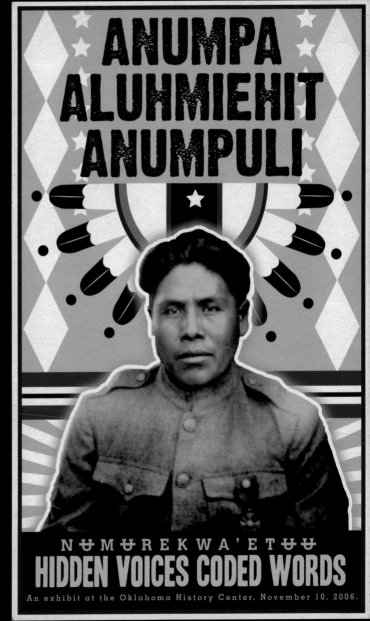

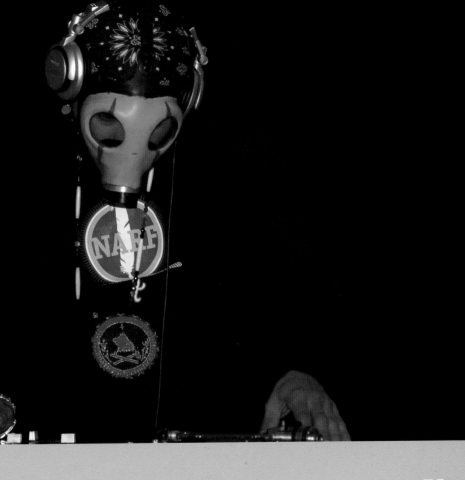

Luane Redeye

(Seneca)

The "discovery" of the Americas and the influence of European culture, values, and technology on Native American society has, in effect, created cultural hybridity. A person of mixed ancestry has a character that consists of layers of reference and language that are further perpetuated by popular culture. In pop culture and media, cultural identity is represented and misconceptions are constructed.

I use my personal experiences of living in contemporary Native America (i.e., reservation life) to create artwork that comments on the concept of hybridity and society's misunderstanding of Native Americans. I also explore the role that images of Native Americans play in popular culture, whether those images create an attraction to or fear of the "exotic" or "savage" Native in this age of modern day warriors.

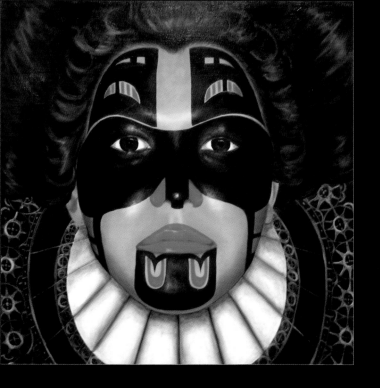

The Mask of Royalty Oil on canvas, 30 x 30 in.

I began incorporating my identity—my "Native Americanness"—into my work by looking into the origins of the combination of American society and Native American cultures. In *The Mask of Royalty*, I juxtapose a sense of Indigenous tradition with European ideologies. A Native ceremonial mask design is tattooed to the face with an Elizabethan collar and hairstyle. This painting represents the interaction and influence of the imperialistic conquering of Native Americans as well as the influence of Native customs and governments on settler society.

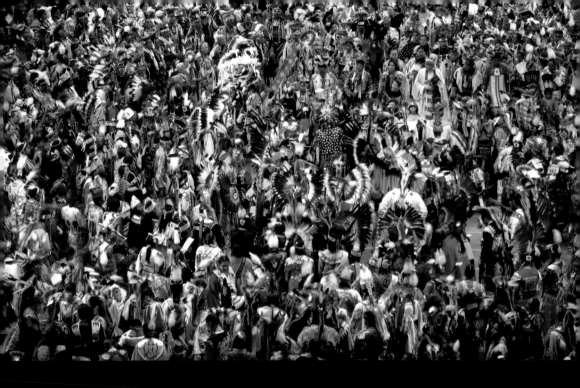

The Gathering Digital photograph, 8 x 11 in.

The Gathering was taken during the Gathering of Nations Powwow (Albuquerque, NM) 2006 Grand Entry. The display of pride and nation is seen through the enormous amount of dancers. Today an "ethnic" person is someone who tries to retain his or her cultural, ancestral heritage, traditions, and customs, while at the same time borrowing from neighboring cultures and societies. Many people think that other cultures do not fit the caricatures or the traditional images that are embedded in society's memories and history, and most "ethnic" artists and people do not embody

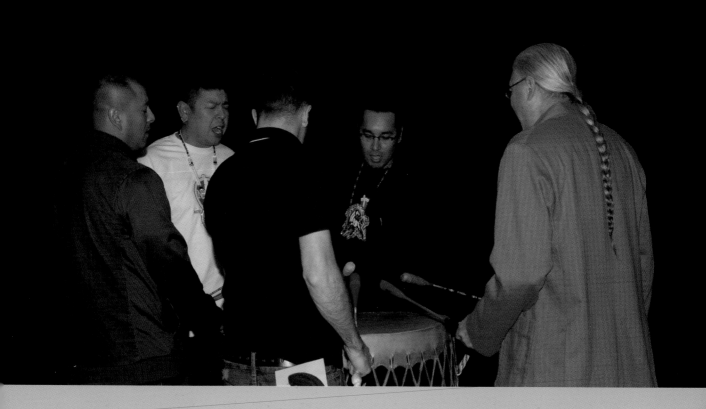

Dawn Webster

(Seneca)

I am a member of the Tonawanda Band of Seneca. I was born in Chicago, but I grew up in Buffalo. During high school, I attended the Buffalo Academy for Visual and Performing Arts. When I was sixteen, I moved to Santa Fe with my parents. I graduated from the Santa Fe Indian School in 1994, worked for two years, went to Santa Fe Community College for two years, then transferred to Haskell Indian Nations University. I received my associate's degree in liberal arts in 2000. I worked for three more years in Santa Fe and then returned to Haskell Indian Nations University. In 2005, I graduated with a bachelor of arts in American Indian studies. Currently, I am working at the Haskell Indian Nations University Cultural Center and Museum in Lawrence, Kansas, as the secretary and research assistant. I also handle much of the collection.

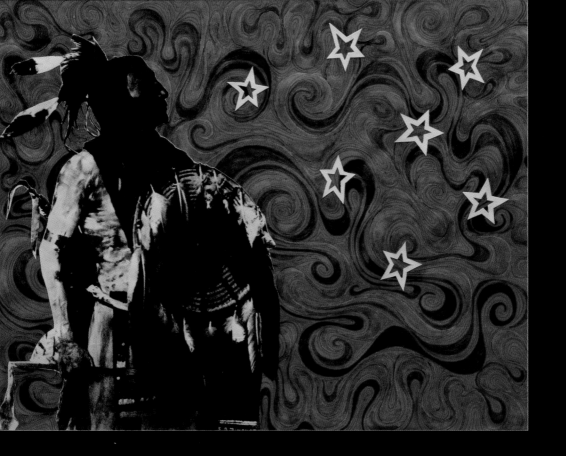

We Are Here Marker and Mod Podge, 11 x 14 in.

This piece demonstrates the preservation of cultural ways. I feel that the stars represent those who have come before us and shown us the way to live. The warrior is fascinated, and his gaze is fixated on them. He is not alone in his endeavors in life.

Micah Wesley

(Muscogee/Kiowa)

I was born on May 13, 1978. I lived with my parents, artist Tillier Wesley and musician Pam Wesley, in Albuquerque, New Mexcio, until we moved to Texas in 1989. I have been drawing and coloring since childhood. I sold my first painting to buy a Nintendo entertainment system. I have worked with various mediums, including acrylic, Prismacolor pencil, enamel, alabaster, clay, wood, small metals, and photography. My subject matter varies between being figurative and nonobjective. I have been labeled a surrealist, a pop-surrealist, and an outsider.

I lost my father and mentor in February 2006.

I've given up on becoming a famous New York artist. I paint, but I wish to spend more time bicycling. I like painting, drawing, or using mixed media.

Self-Portrait

Acrylic, 48 x 24 in.

I painted this a couple of
months after my father died,
and I had painted numerous
self-portraits. I was falling
hopelessly into a void. Alcohol
and drugs consumed me,
and I couldn't run any farther
away from myself. I woke up
in an emergency room with all
kinds of cords attached to me,
and I was fully exposed to the
world. After pulling through the
breakdown, I painted a self-
portrait of all my insecurities
and irresponsibilities, of what
I felt like during the fall to the
great below.

Rebel and Be Cool

Pencil and ink, 9 x 9 in.

I'd seen and heard of many pointless tattoos, so I wanted to start making some flash some people could really dig. I wanted the look of some traditional sailor and Chicano styles with an Indigenous and rockabilly motif. *Rebel* is about strength, family strength. *Be Cool* is aimed toward males, to be cool, and cool off, Daddy-O!

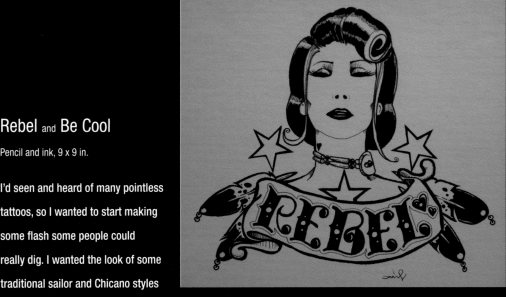

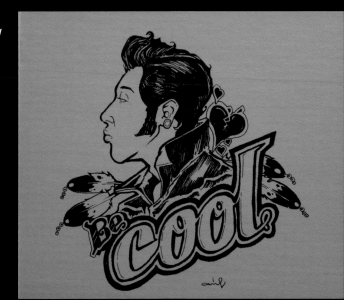

Best in Show

Best-in-show winners Duane Dudley, Cara McDonald, and Thomas Ryan Red Corn were flown to Boulder to attend the art show as well as the Visions for the Future award ceremony honoring them and their work. Three of their pieces were submitted to a team of journalists, artists, and the Native American Rights Fund (NARF) staff comprising the jury who chose the first-, second-, and third-place winners. Daniel and B. C. Echohawk, relatives of the late and well-known Pawnee painter Brummet Echohawk, pledged $500 for the first-place winner. The second-place winner was awarded $300, and the third-place winner $150. John Echohawk, Don Ragona (NARF development director), and Crystal Echo Hawk (assistant development director)

headed up the awards ceremony honoring the winners.

Dudley and his piece *Did You See the Game?* won the first-place prize, the Brummet Echohawk Memorial Award. The Visions for the Future jury was moved by the way this young artist captured the bridging of two worlds with his pastel of the two men participating in a Native American Church ceremony while also catching up on their favorite sports event.

McDonald's *We Gather Together* was awarded second place. The jury responded strongly to this piece for the way that McDonald captured through her lens and artistic styling the strength, resiliency, and different ways that Native peoples today practice and engage in their spiritual lifeways, whether through traditional ceremonies or through the contemporary church.

Red Corn's *Vandalism* was awarded third-place honors. Red Corn's piece was selected because of the strong visual, social, and political statement that it conveys regarding Lakota and other Native peoples' feelings toward Mount Rushmore and the Black Hills. Many Native peoples view Mount Rushmore as a desecration of the Black Hills, which is one of the most sacred sites to the Lakota people. The irony of the "vandalism" statement depicted in his graphic illustration encourages viewers to consider the Native perspective on not only this issue of Mount Rushmore, but for all sacred sites of Native peoples.

Acknowledgments

The Native American Rights Fund (NARF) wishes to convey its heartfelt thanks to the Visions for the Future featured artists for their support and to all the young artists who submitted work for consideration. These young artists' perspectives and voices conveyed through their art is a powerful means in which to hear from the current generation of young Native Americans about Native rights, issues, and cultures.

Many thanks also to our sponsors. Your support of NARF makes a difference!

Special thanks to our major sponsors:
Turquoise sponsors:
Belgarde Enterprises
The Inez C. Moss Family of Pechanga Band of Luiseño Mission Indians

Granite sponsors:
The Ungar Foundation
John Bevan
The Republic of Boulder

Flint sponsors:
The Eugene and Emily Grant Family Foundation
Brickmill Marketing Services

for the Future artists; all of the young Native artists who submitted artwork for consideration; our musical performers, "Quese IMC" Frejo and Brian Frejo of Culture Shock Camp; DJ Lazy Eyes and DJ Thought of Basementalism Radio; artist Bunky Echo-Hawk for his live-art performance and generosity in donating for auction the painting he created; Charles Wilkinson; our NARF staff, Mireille, Don, Jennifer, Ray, and Rose; and our many volunteers, including our curator Charmain Shuh; Carly Hare; Carmen Ramirez; Doug Foote; Jenni Monet; Todd and Karen at The Republic of Boulder; Santiago at Santa Fe Arts; and numerous others who supported NARF and this event.